Sometimes simple actions can make you feel comfortable and secure without your knowledge. When the rigid force is released, you have a clear perspective, and when you let go of your thoughts, understanding permeates from the living truth.
That is the 'wisdom' within us.

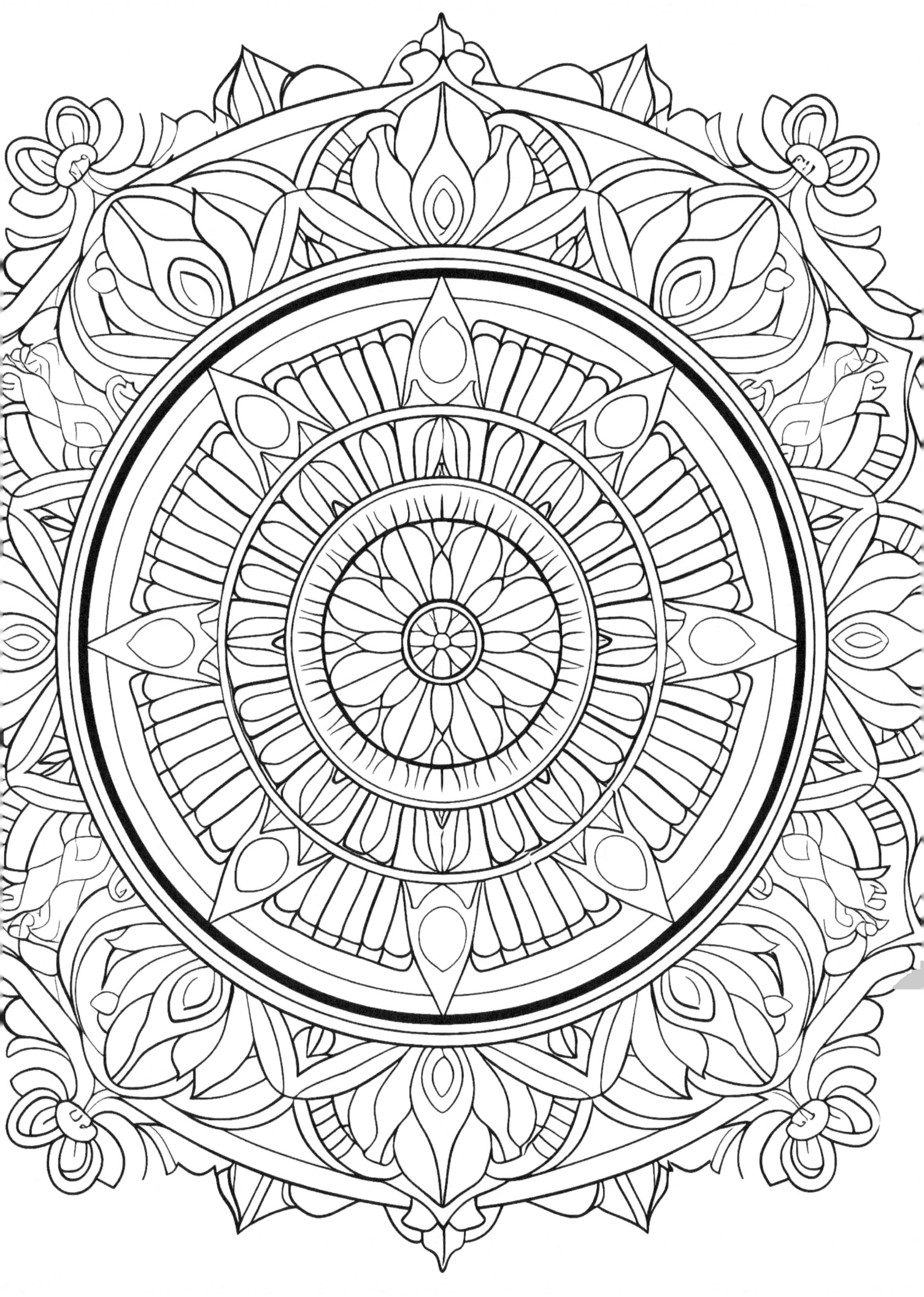

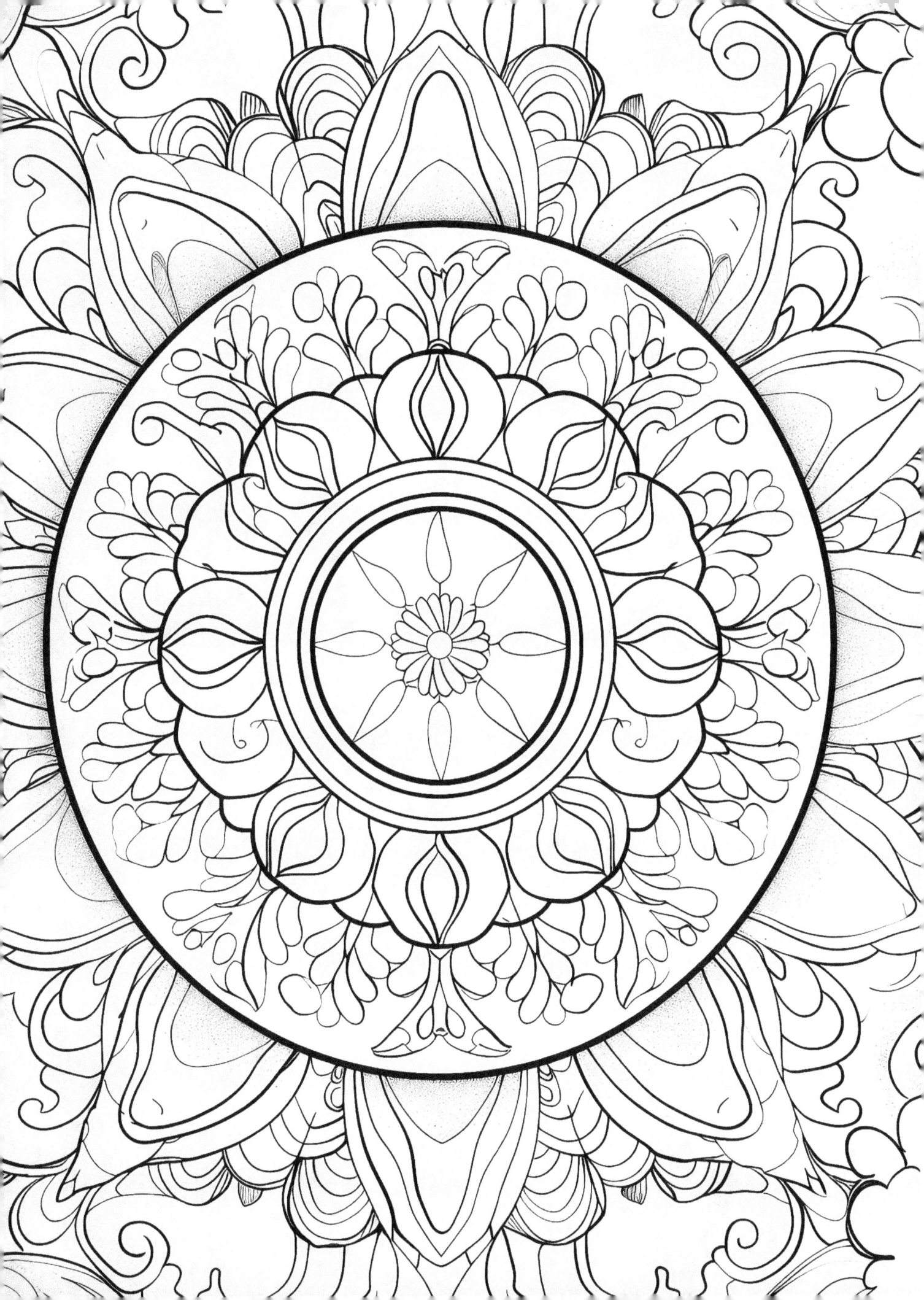

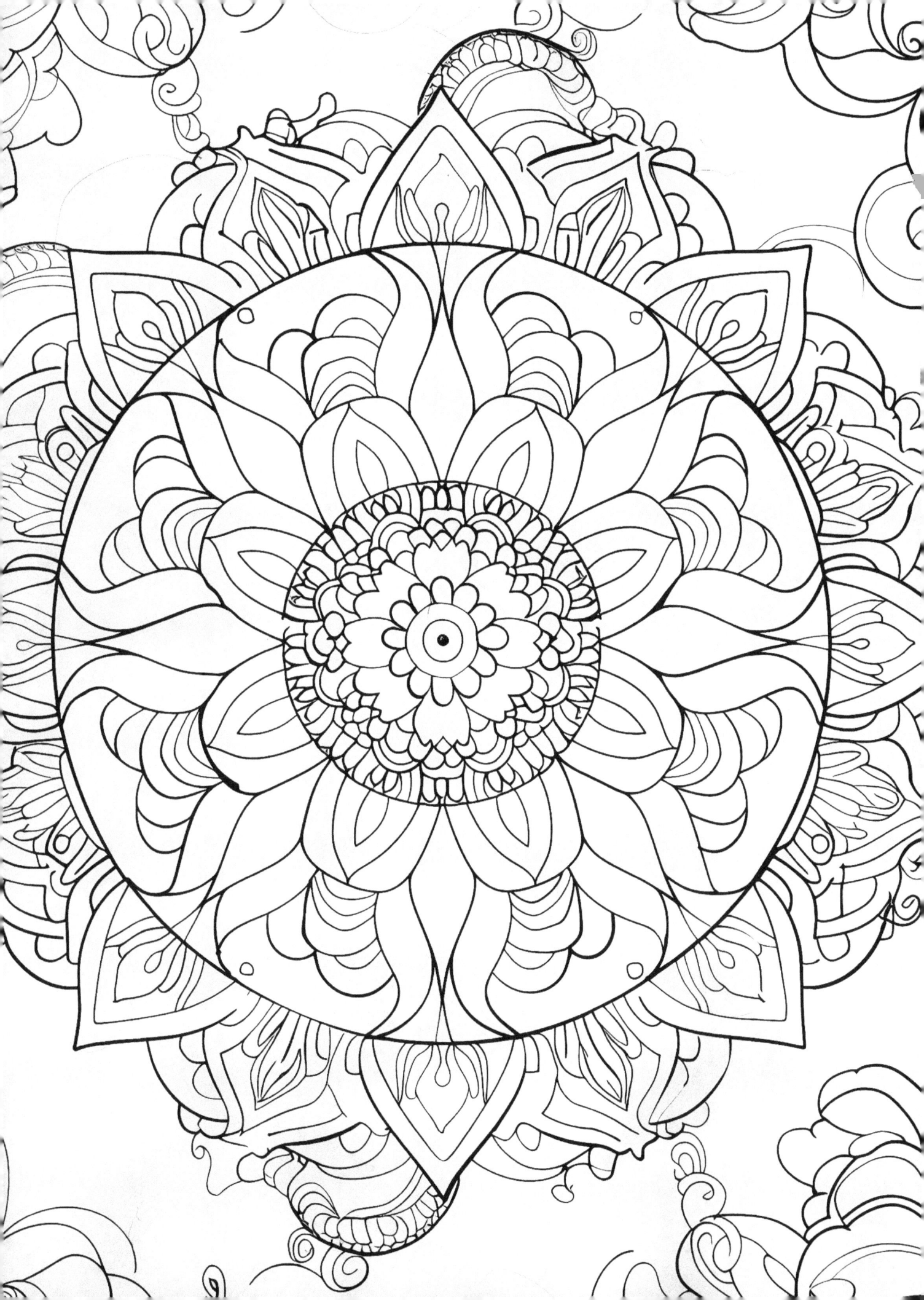

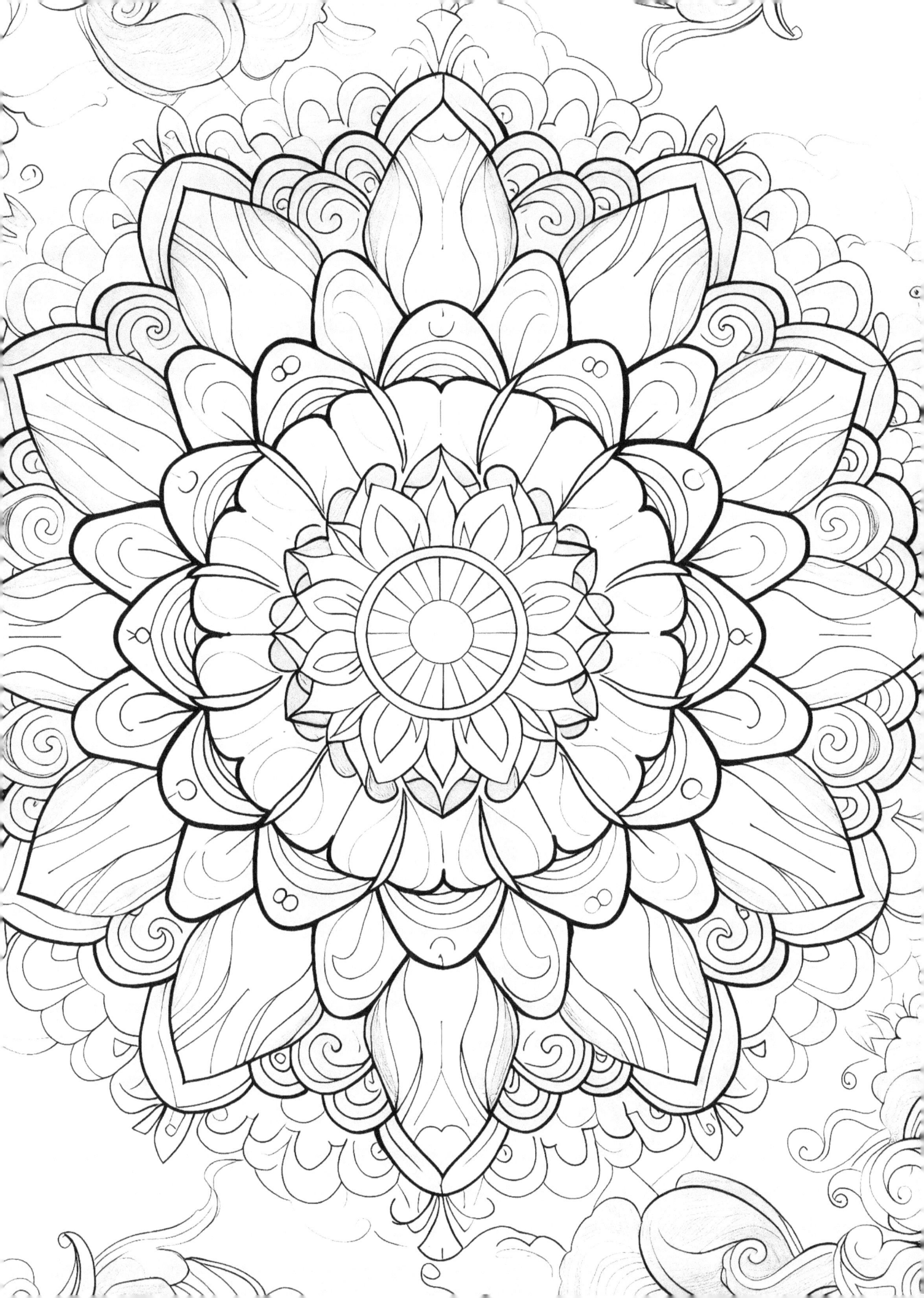

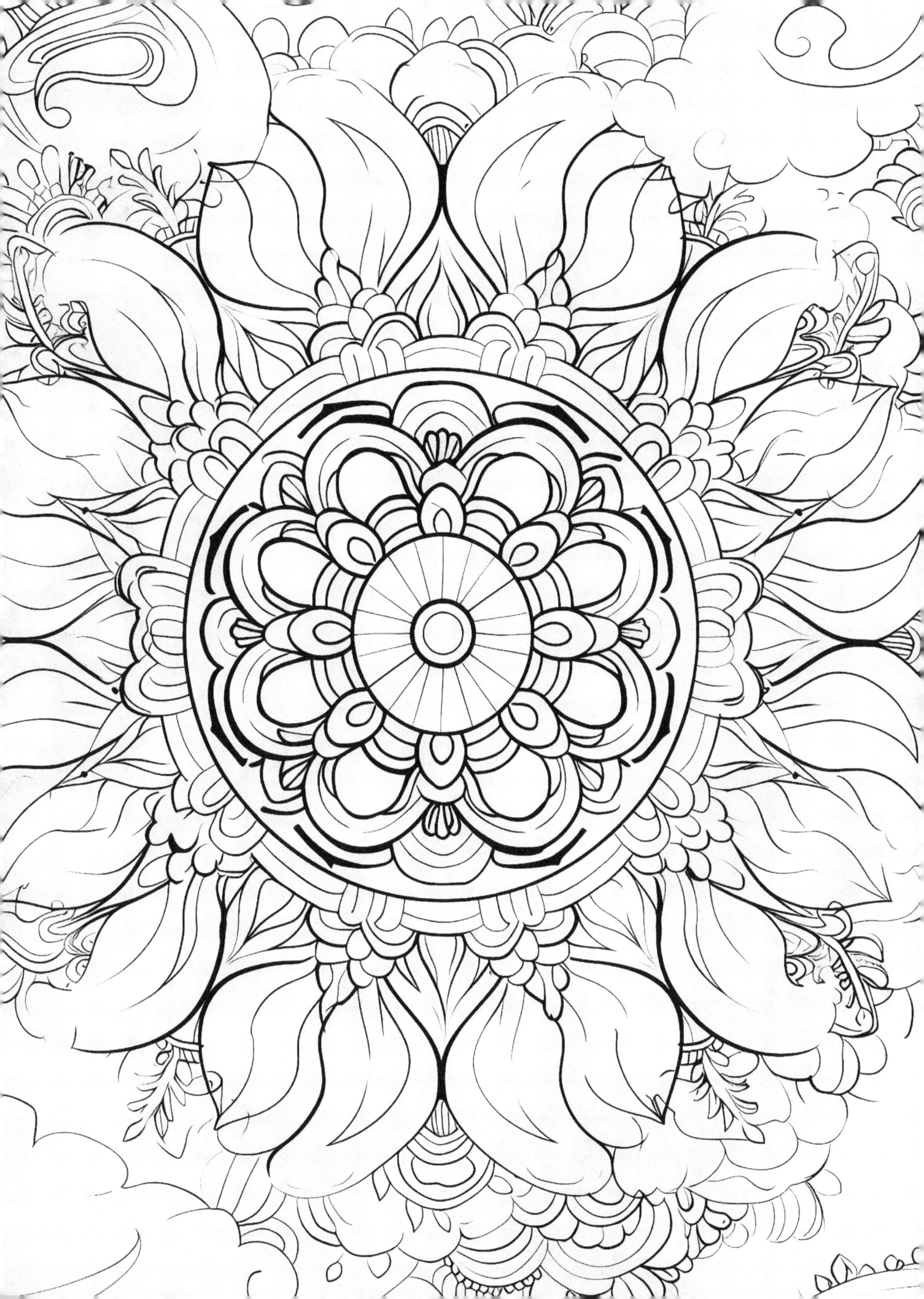

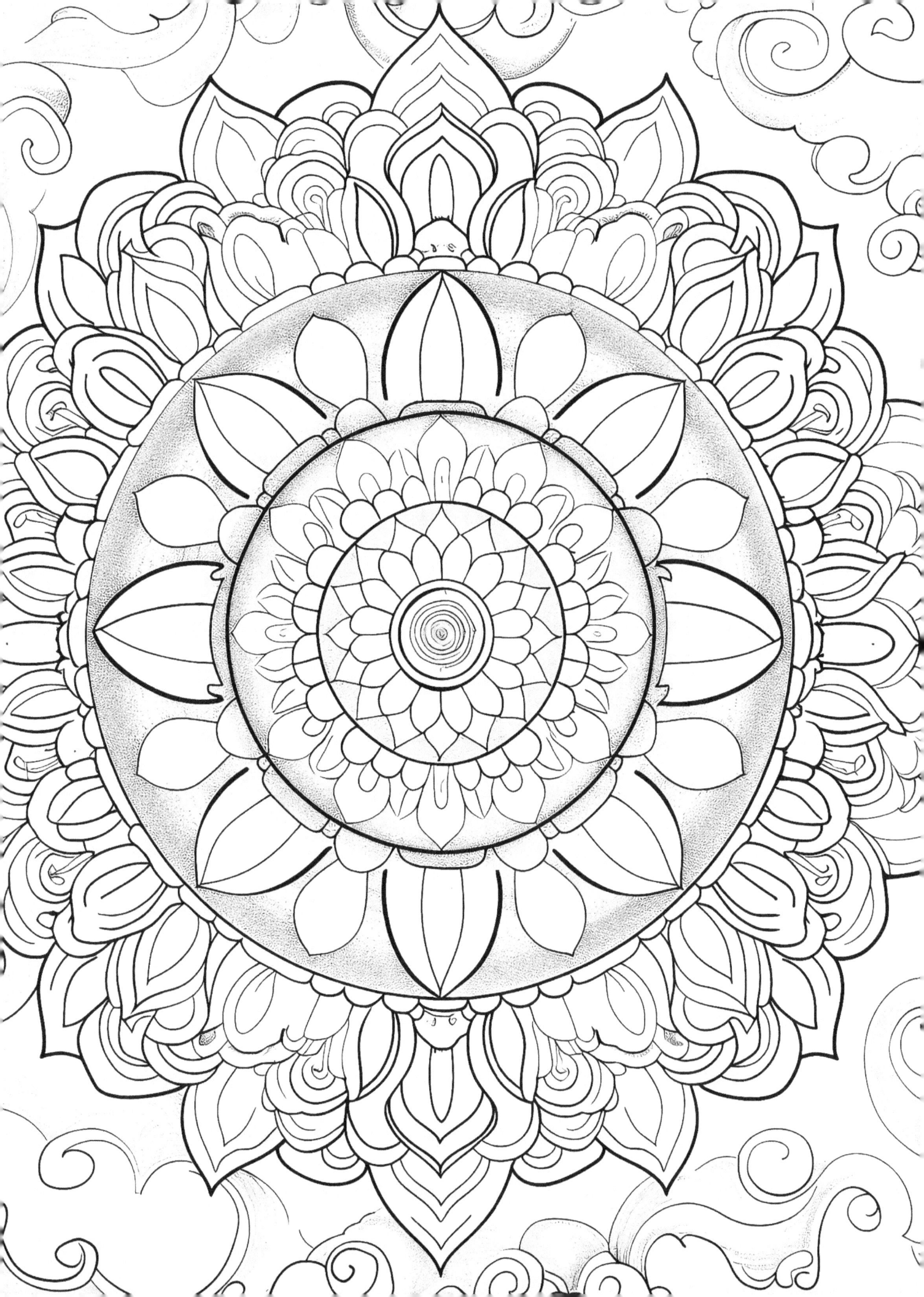

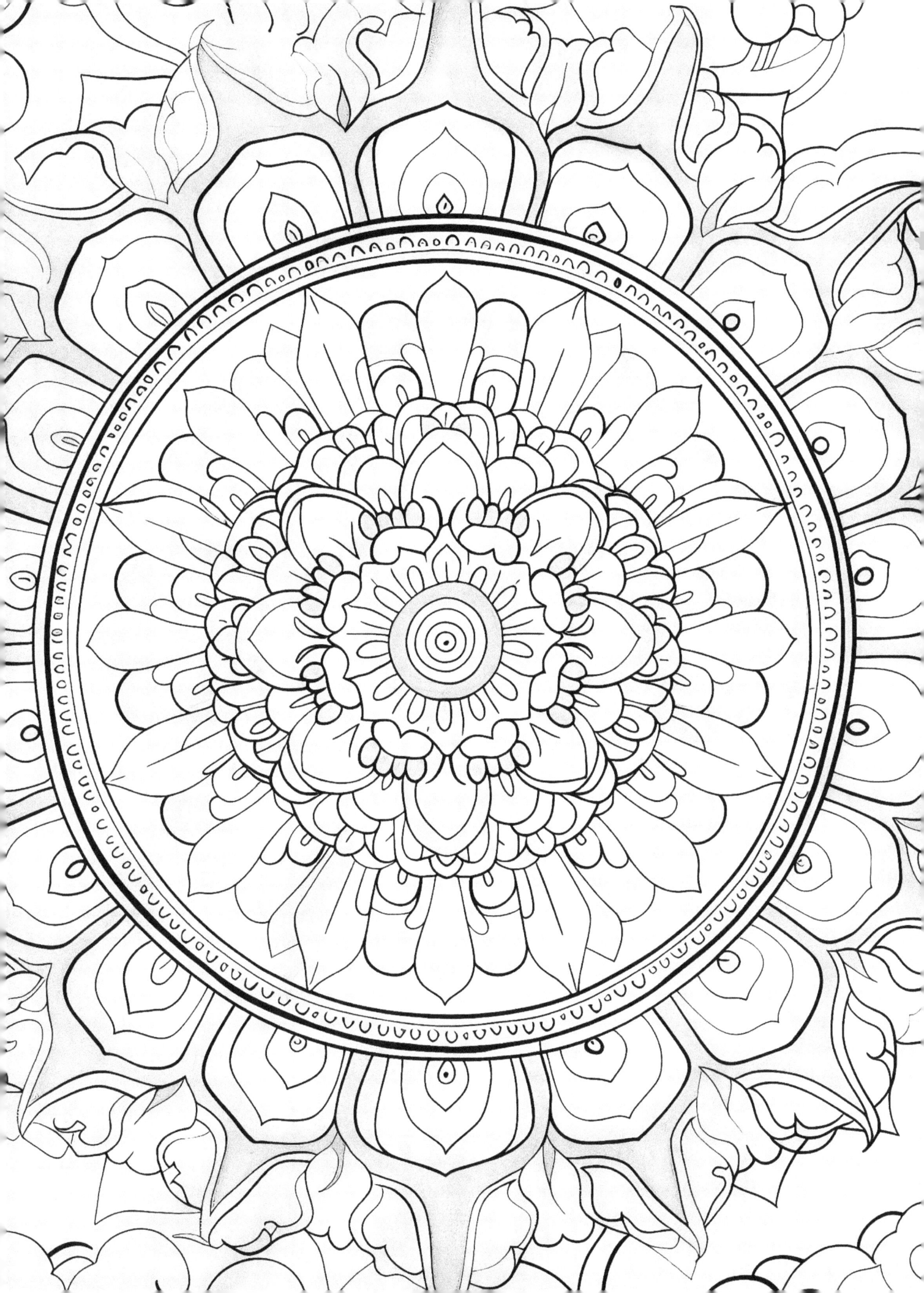

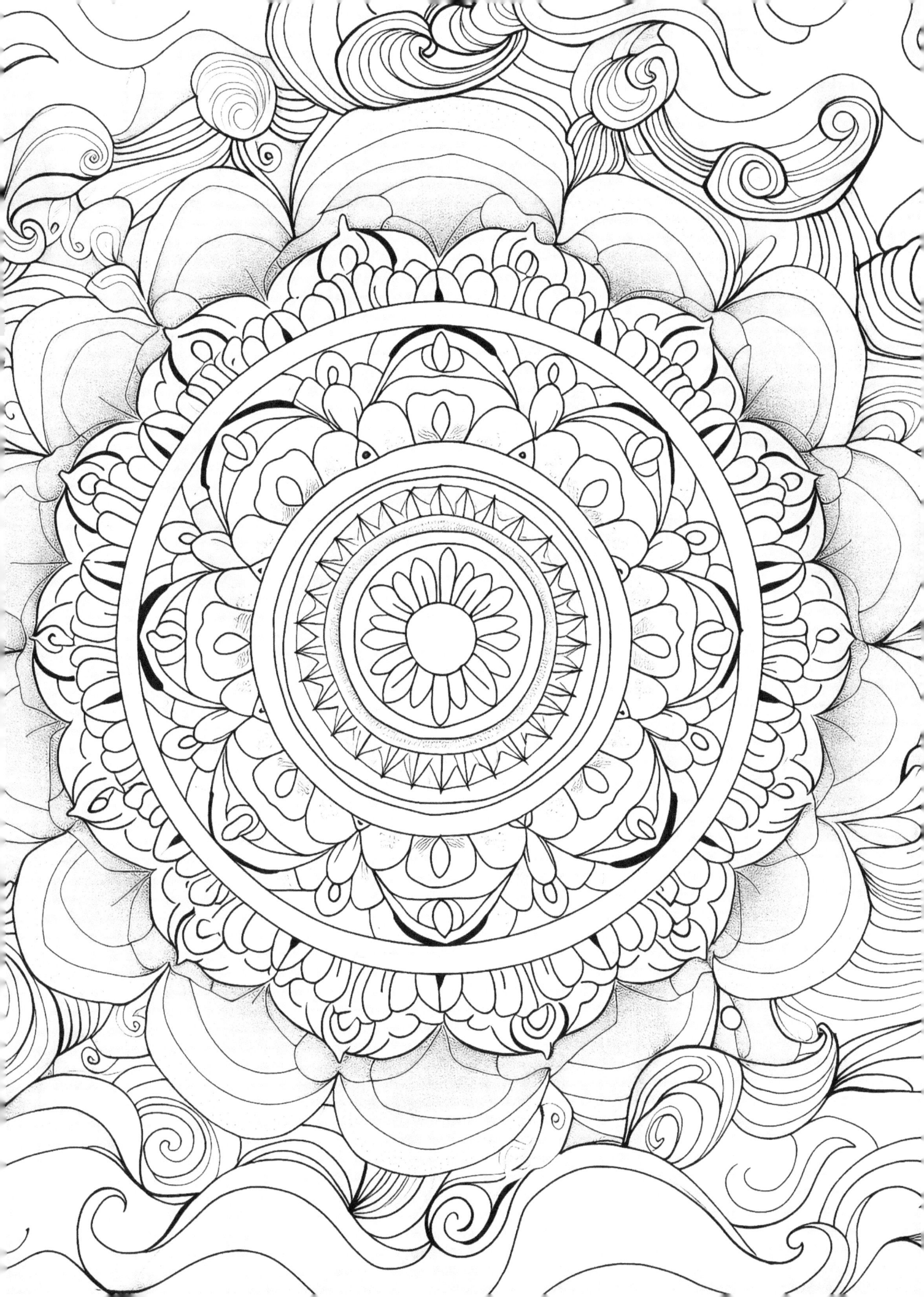

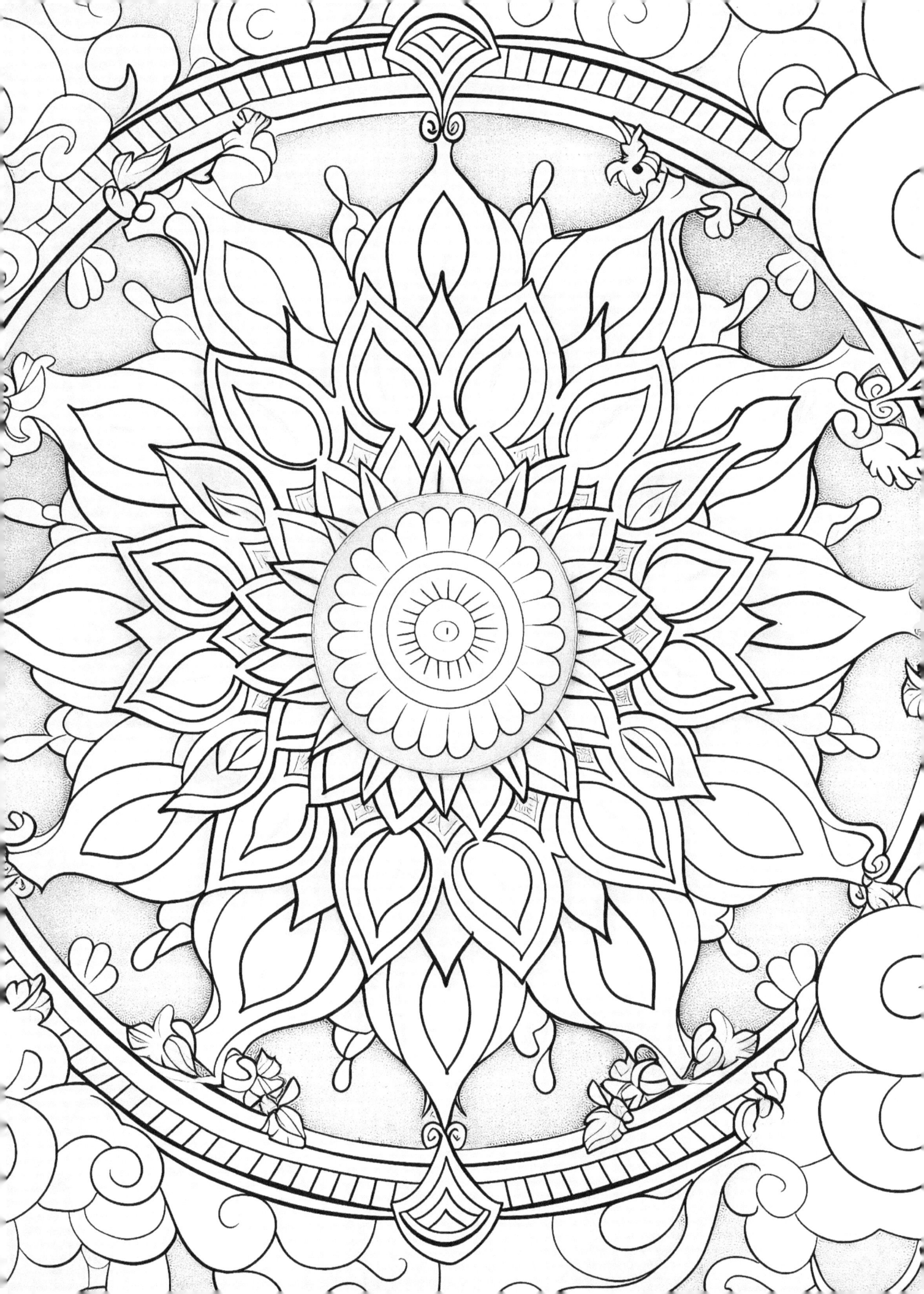

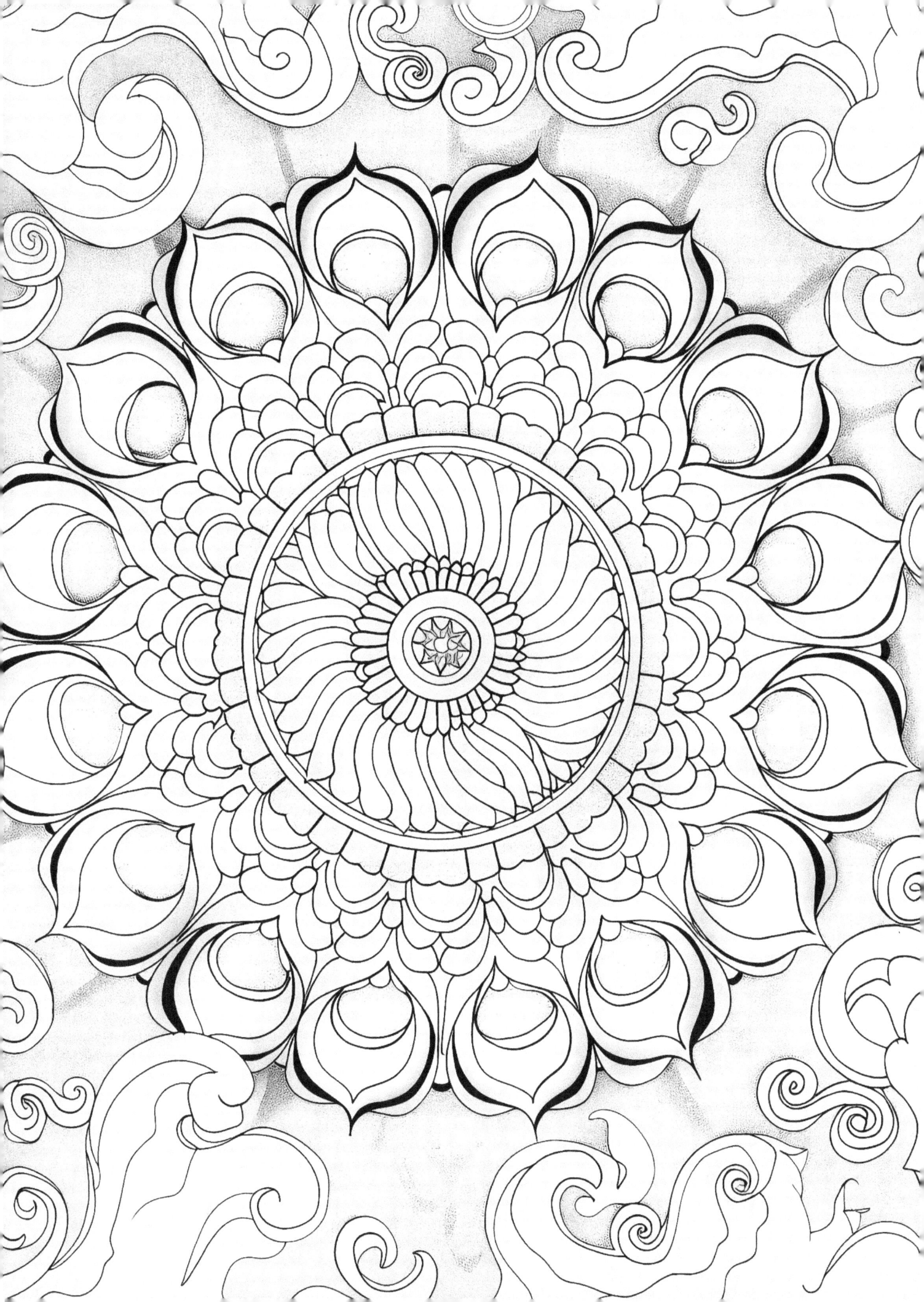

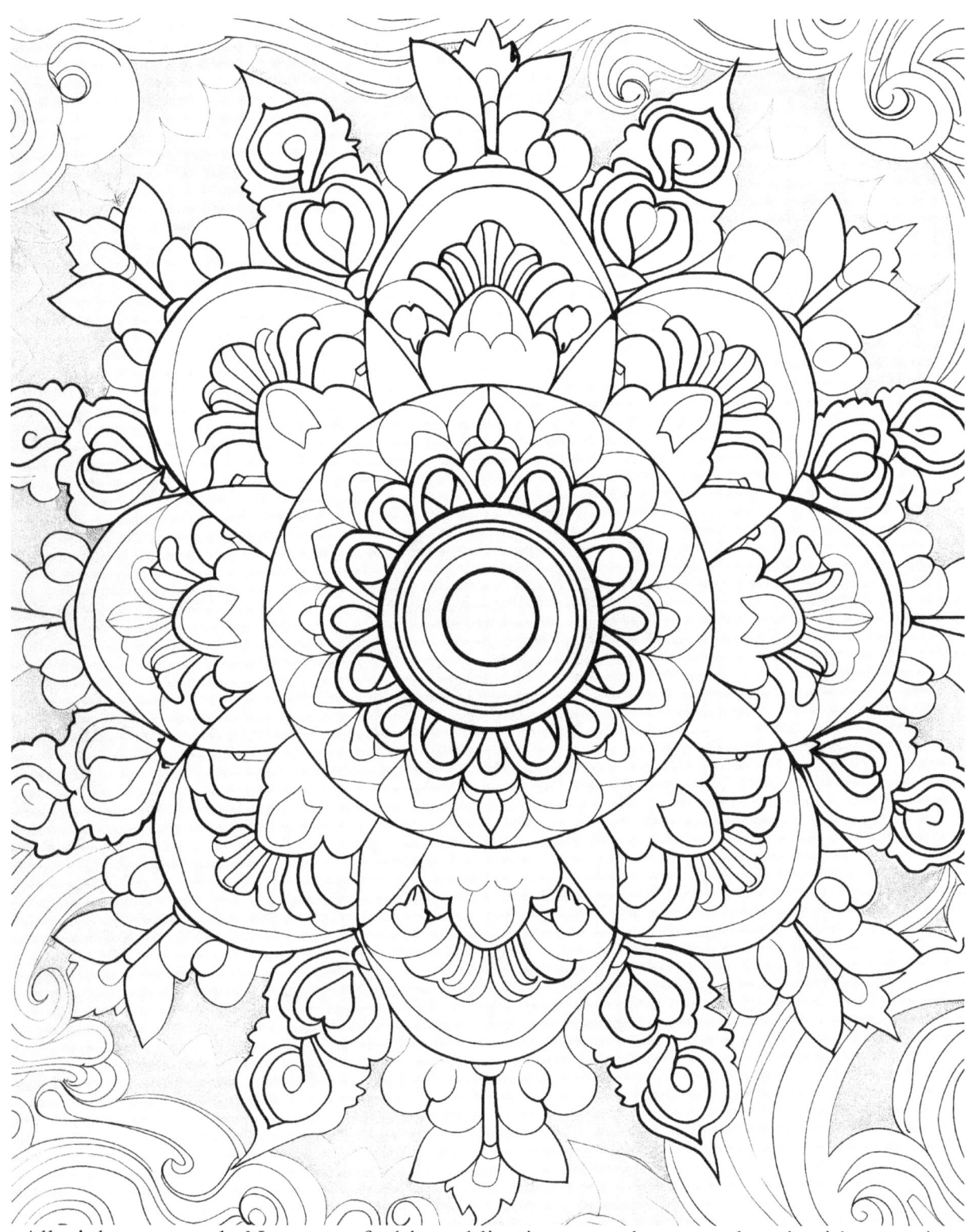

All right reserved. No part of this publication may be reproduced without prior the written permission of the publisher and copyright owner.
Published by EMERALD PINK STUDIO

emerald-pink.com

www.ingramcontent.com/pod-product-compliance
Lightning Source LLC
Chambersburg PA
CBHW082241220526
45479CB00005B/1307